A
JACQUES LOWE
VISUAL ARTS PROJECTS
BOOK

© 1994 by Jacques Lowe

Book design by Joseph Guglietti. Jacket design by Anne Shannon.

Typeset in Cochin and Gill Sans. Printed in Hong Kong.

LIBRARY OF CONGRESS CATALOGING-IN-PUBLICATION DATA
Lowe, Jacques
Looking at photographs–people / text by Jacques Lowe; photographs selected by Jacques Lowe.
48p. 21.6 x 28 cm. Includes index.
ISBN 0-8118-0446-1
1. Portrait photography—Juvenile literature. 2. Photojournalism—Juvenile literature.
3. Photography, Artistic—Juvenile literature.
[1. Portrait photography. 2. Photojournalism. 3. Photography, Artistic]
I. Title.
TR680.L647 1995
778.9'2—dc 20 94-26280
CIP
AC

Distributed in Canada by Raincoast Books
8680 Cambie Street, Vancouver, B.C. V6P 6M9

10 9 8 7 6 5 4 3 2 1

Chronicle Books
275 Fifth Street
San Francisco, California 94103

People

by
Jacques Lowe

Chronicle Books　San Francisco

Introduction

The invention of photography in the nineteenth century was something like solving a jigsaw puzzle. Many of the pieces—such as the camera, and the lens, and the knowledge that exposure to light affected certain materials—had been in place for centuries. The first permanent photograph was made in 1826 by Nicephore Niepce. However, not until 1839 did a Frenchman, L.J.M. Daguerre, and an Englishman, W.H. Fox Talbot, announce to the public two methods for making photographs. Ever since, photography has been changing the way we see our world. One example is what photography has shown us about how people around the world live.

Before the invention of photography, painters, etchers, and other graphic artists were limited in showing the full range of people's activities. And in the early days of photography, the large, heavy cameras and long exposures that were necessary restricted photographers in much the same way. By experimenting, some of them, like Jean-Eugéne Auguste Atget, in his studies of "Paris Life," found ways of overcoming those obstacles by photographing only in good light and at certain times of the day. Since then, cameras have become much lighter, and films much faster. Today it is possible to photograph the habits and details of people's lives in even the remotest parts of the world, letting us experience events taking place thousands of miles away from our homes.

Over the past century and a half, photographers have taken hundreds of thousands of pictures of people. Within these pages, you'll find photographs of Native Americans by Edward S. Curtis, photographs of circuses in India by Mary Ellen Mark, pictures of celebrities by Douglas Kirkland, and a photograph of an embryo inside a womb by Lennart Nilsson.

But this book isn't just about people; it is about photography. And understanding photographs is an important skill. This book will help you learn about how photographs are made, what they have to tell us, and how we can get the most out of looking at them carefully. You can apply the ideas you'll find here not only to pictures of people, but to the many different kinds of photographs that come into your life every day. We hope that it will change the way you look at and think about all photographs.

THE ORGAN GRINDER, 1901
Jean-Eugène Auguste Atget, French

Jean-Eugène Atget was born in the southern French town of Bordeaux. Orphaned at an early age and raised by his uncle, he left home and spent his early years as a sailor. After returning from the sea he moved to Paris, where he became an actor, but with little success. Determined to find an outlet for his artistic aspirations, he considered becoming a painter. But instead he joined a new breed of artists: photographers.

Atget made it his goal to document everything beautiful and important in his beloved Paris. He set himself specific assignments—to photograph the historic buildings, monuments, shopkeepers, and beggars. Each subject became a series of hundreds of photographs which he sold to museums and to painters.

Atget liked to work early in the morning. Because of that, his images glow in a very soft morning light. But his pictures are very sharp and every detail is clear because he worked with a large view camera on a tripod. These cameras were cumbersome and heavy. Roll film had not been invented yet, so the photographer had to use glass plates coated with silver, which needed long exposures. He toned the final prints with gold chloride, which gave the pictures a very warm look.

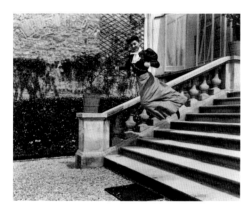

Jacques-Henri Lartigue,
BICHONNADE IN FLIGHT
Lartigue, a young boy who started to photograph his family and friends in the early part of this century, took snapshots of his family in motion, using one of the first hand-held cameras.

Atget did not receive any public recognition for his work. While he was alive, not one of his pictures was ever published in a photo magazine, the publications where photographers showed their work. Eventually Berenice Abbot, a famous American photographer living in Paris at the time of Atget's death, rescued his negatives from obscurity, preserved them, printed them, and arranged for exhibits. Because of her this rich heritage is preserved, and we can see today how Paris and the Parisians looked at the turn of the century.

Though old-fashioned in his technique, Atget was very advanced in his vision of what photography could accomplish. Unlike most photographers of his time, he avoided taking photographs that looked like paintings and instead posed his subjects in realistic and natural ways. When his work was first shown in America, young photographers were inspired by his straightforward approach. His pictures documented a culture in a revolutionary way and his work became the forerunner of *photojournalism*.

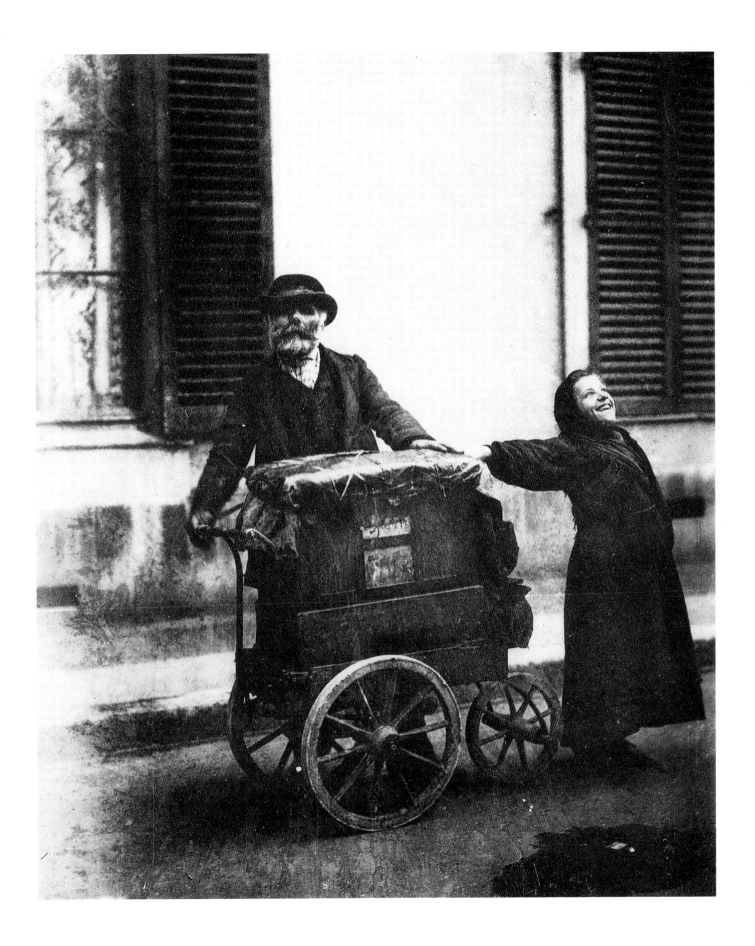

BEAR'S BELLY-ARIKARA, 1908
Edward Sheriff Curtis, American

Edward Curtis fell in love with photography as a boy. Before he was sixteen years old, he had built his own camera and taught himself the basic technique of photography. By the age of twenty-seven he had become the most successful *portrait photographer* in Seattle, Washington. It was at his studio in Seattle that he encountered Native American people for the first time. They came to have their portraits taken. He soon became fascinated with Native American culture and obsessed with recording it.

Curtis decided to publish a series of books called *The North American Indian*, and for thirty years he roamed the country photographing about eighty native nations. In the process, he also recorded their music and languages, described their spiritual, religious, and social customs, and explained how they gathered and cooked their food. In the process he spent all his money, lost his wife and family, and finally fell terribly ill from overwork and exhaustion. But his dedication resulted in nearly five thousand photographs — which is the most complete visual documentation we have of Native American culture at the turn of the century.

Because Curtis posed the warriors, chiefs, and medicine men directly, either facing the camera straight on or in profile, they all look very regal. We can see pride in their faces and poses. Curtis also paid very close attention to native dress, picturing in detail the clothes, headdress, and jewelry his sitters wore. His use of daylight, streaming across the picture from the right or left, often leaving one side of the face in shadow, created a very strong contrast and enhanced the powerful look of some of the warriors' faces. He used a large format camera mounted on a tripod. This enabled him to have long *exposures*, which gave him great *depth of focus*, thus making his pictures very sharp. We can clearly see the deep lines in his sitters' faces and the wrinkles in their hands.

By the time he died in 1952, Curtis's work was nearly forgotten. But today, his portraits are considered to be among the finest ever taken of Native Americans.

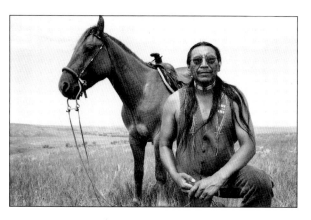

Dan Budnik, ARVOL LOOKING HORSE
Dan Budnick also has devoted much of his life and work to creating images of Native Americans. This image of a Hopi chief is not much different from those taken by Curtis. Only the sunglasses reveal the difference in time.

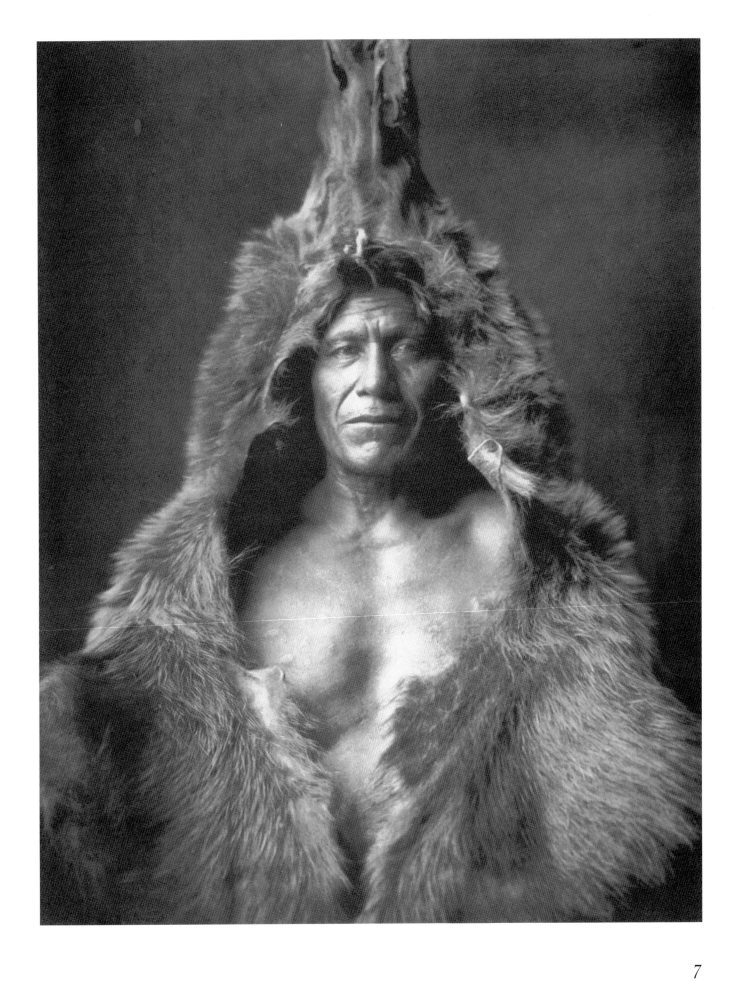

POWERHOUSE MECHANIC, 1920
Lewis W. Hine, American

Lewis Hine was a sociologist. He began to photograph in 1905, using the camera as a research tool. Concerned about the mistreatment of laborers, he used his camera to record how small children were exploited by having to perform jobs meant for grown-ups. He did this by contrasting small children with the massive machines in the factories where they worked. Because the factories were very dark, he used flash powder, which was invented in Germany in 1887. When ignited, this highly explosive powder burned in a flash, thus making it possible for photographers to take pictures without any natural light.

When Hine's work was first published it was called a *photo story*, which meant the photographs told a story. Because his pictures were such powerful documents, they received a lot of attention, and led to laws being passed on how workers, especially children, should be treated in the workplace. He called his work "photo interpretations" and "human documents." He still didn't think of himself as a photographer, but as a scientist who experimented with photography.

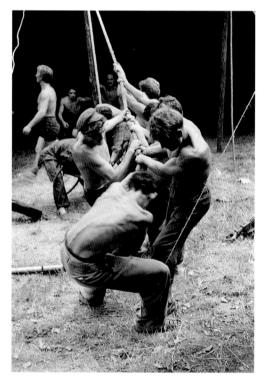

Jacques Lowe, CIRCUS HANDS, FRANCE
This picture also shows people at work, but differs from the one opposite in that it features no machines. Instead it concentrates on the raw human strength of the workers.

Eventually Hine's interest in photography grew. This picture is part of a series he published on workers in a book called *Americans at Work*. He took pictures every day during the construction of the Empire State Building, designed to be the highest building in America at that time. Following the workers from floor to floor, he walked the narrow steel girders at dizzying heights, carrying his heavy camera and tripod, experiencing what the workers experienced.

Eventually Hines's photographs, and those of other photographers working in similar ways, became the inspiration for a new medium in motion pictures called a *documentary* .

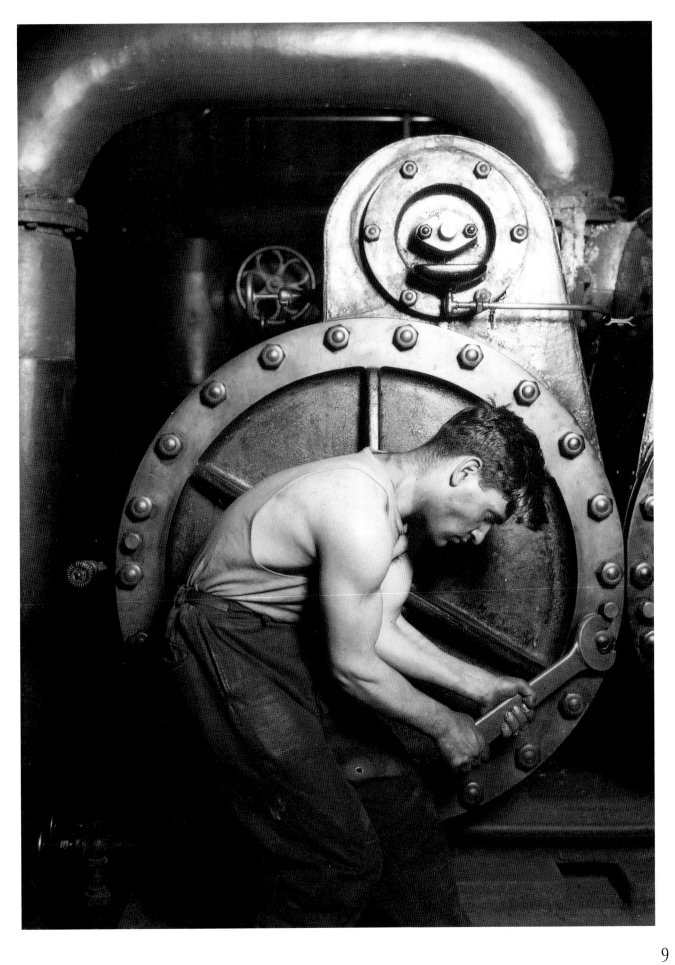

MIGRANT MOTHER, NIPOMI, CALIFORNIA, 1936
Dorothea Lange, American

Dorothea Lange was a successful portrait photographer in San Francisco when the Great Depression hit America. The stock market crash of 1929 devastated families from all walks of life. Millionaires became paupers, shopkeepers lost their stores, and workers suddenly lost their jobs. Homeless people roamed the streets. Food lines formed near every church and every government office. It was a terrible time in America. Dorothea Lange believed that if she could document the misery through her photographs she could get others to help.

President Franklin Roosevelt agreed with her and, in 1935, set up the Farm Security Administration. This agency asked America's finest photographers to help defeat the Great Depression by documenting the plight of those who had lost their livelihoods, especially the migrant farm workers of the American heartland. Through photography, the agency hoped to educate those more fortunate to understand why certain laws were necessary to restore the health of the country.

Dorothea Lange roamed the country, following the migratory workers' trek across America, and in the process she created some of her finest work. Her pictures showed the poverty, pain, and hopelessness of people caught in a fierce fight for survival. She pointed her hand-held camera straight at her subjects, sparing no emotion and softening no detail. This picture of a mother is one of the finest examples of Lange's compassionate work. The lifeless eyes staring inward, her look of despair, and the children hiding from the camera in shame clearly reveal the nightmare all of them are facing. The baby in her arms is covered in rags. The bit of canvas peeking out in the back shows that she is living in a tent, not a house.

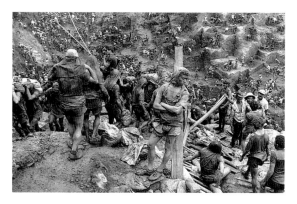

Sebastiao Salgado, GOLDMINERS
Salgado's powerful images of laborers are reminiscent of Lange's work, but his images are more sweeping in scope.

Dorothea Lange was one of the first true *documentary photographers*. Her work had an enormous impact by reflecting the despair and deprivation the Depression inflicted on many Americans. LIFE Magazine, started in the same year as this picture was taken, was the first American magazine devoted to the documentary style, also called *photojournalism*. These pictures have helped us feel as though we were part of events, even when they occurred far away, and helped us better understand the world around us.

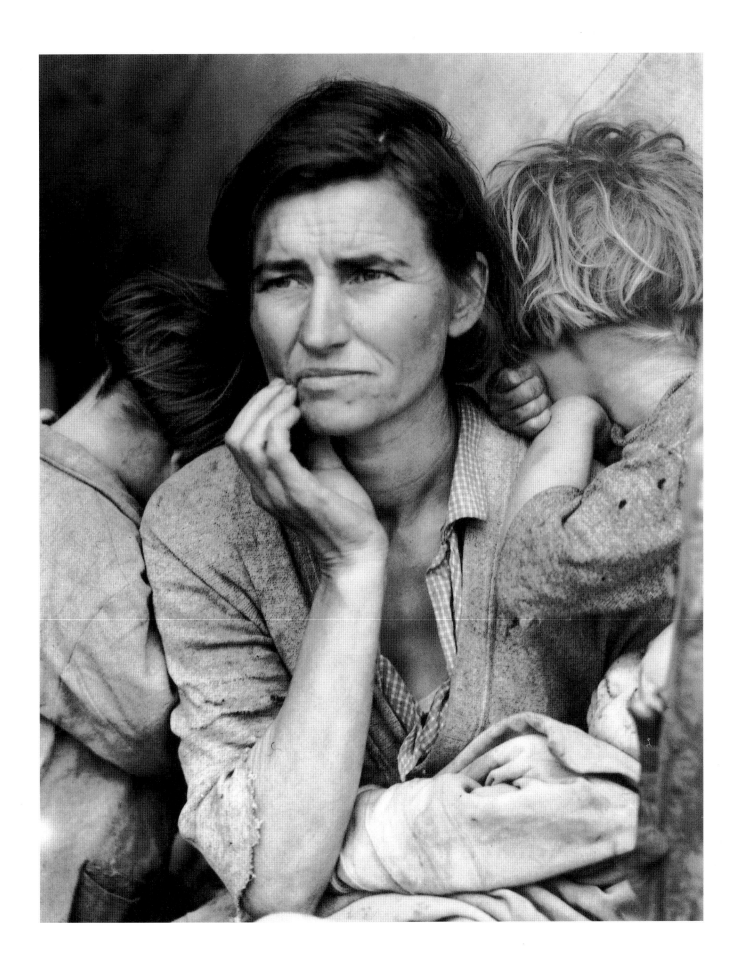

NEW YORK, 1940, 1940
John Phillips, American

As we can see in this book, photographers are attracted by very different subjects. Some specialize in photographing models and fashions, some shoot portraits of famous people. Still others prefer to take *news pictures* or to explore foreign lands. But every photographer at some point tries to explain relationships, because relationships are a part of everybody's daily life. We love our mothers and fathers, our sisters, brothers, and friends, and we do things to express that love. Photographers try to capture these fleeting, intimate moments, but because these moments are very personal, it is very difficult to catch them on film. When such a picture is successful, as these two are, we see not only what the people in the photograph look like, but also how they relate to one another.

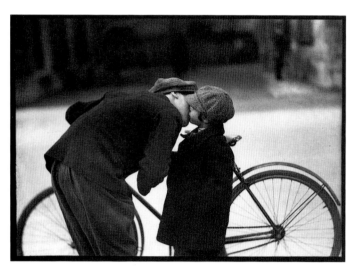

Hans Staub, IN FRONT OF THE NURSERY SCHOOL IN THE INDUSTRIAL SECTION, ZURICH, 1931
This photograph, made in 1931 in Europe, and the one opposite, made ten years later in America, show us that relationships are similar everywhere.

Different people express love in different ways. This photo of a father blowing a tuba while his little boy sits in the bell blowing a trumpet is funny, precisely because they are both so serious about making music. If they were laughing and looking at the camera, it would not be such a successful picture — it would look posed, and therefore not real. The little boy imitates his father exactly, and we know that he admires his father and wants to be like him. Through this simple picture, we learn much about these two people.

The picture on the left tells a different story. The father is going off to work and the boy to his nursery school. This father and son are obviously saying goodbye to each other with a kiss. The kiss tells us that they love each other.

But it is not just the feeling of love that photographers try to capture. Another photograph might show the very opposite of love — anger, or even hate. If you look at a photograph up close and can see exactly how the people shown feel about each other, then it is a successful picture.

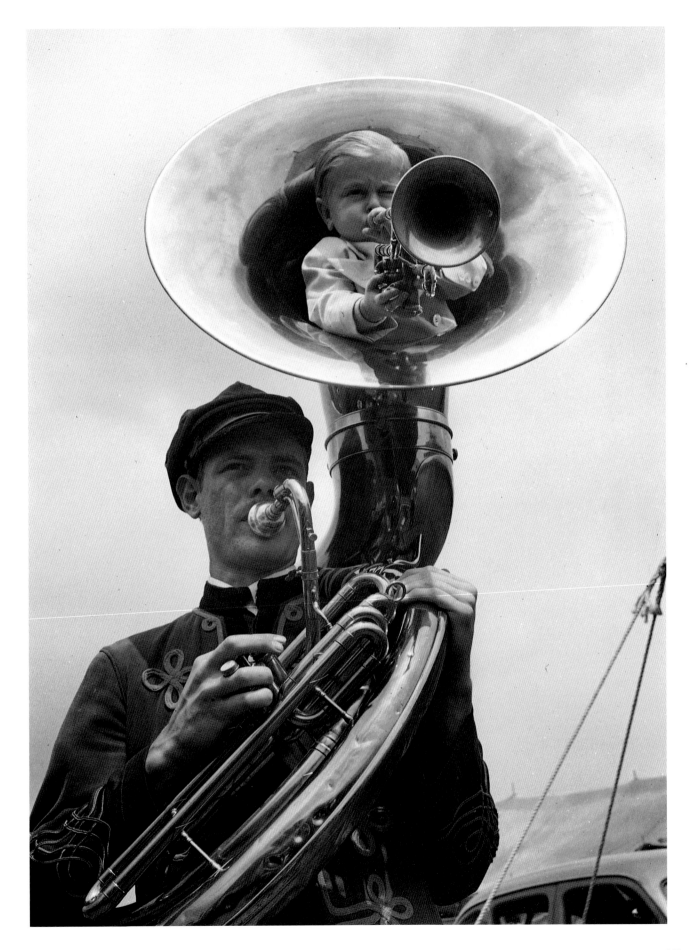

NOW YOU SEE ME..., 1959
Jacques Lowe, American

Very often photographers use those closest to them as their subjects. Because the photographer knows them so well, families and friends often make the best subjects.

These photographs are often called *snapshots*. But although many people consider them casual or unimportant, snapshots often have a very lasting value. They remind us of times gone by and they re-create a time and place by showing us the clothes our friends and relatives wore, the things they did on a particular day, and the environment in which they lived.

This photograph of the photographer's son, Jamie, was taken on a lazy summer afternoon by the sea. Jamie covers his face, hiding, but we see his eyes and they are smiling. Because of this we know that he's happy, that he's playing a game, rather than hiding because he's afraid of something. And because the background is very simple there are no distractions from the central point of the picture. We instantly understand its meaning: Jamie is playing hide and seek with the camera.

Both of these photographs were taken with a large camera that takes square pictures, a shape the photographer liked for portraits. The photographer kept the camera out in the open all the time so that Jamie would get used to it. It became a part of his life, and he learned to ignore it. Because the photographer wanted to create the most relaxed images possible, he worked only during daylight hours. By using only daylight he was able to capture events as they happened, without any lights to set up, without any preparations. These kinds of snapshots are also called *candid photos*.

As you get ready to make a portrait, it is important to think about what kind of image you want to create. Elaborate preparations for a photograph are only necessary if the portrait is to be formal. But if a candid photo is wanted it is better to make no preparations at all. This helps to create an image that shows the subject in a natural and relaxed pose.

Jacques Lowe, FIRST LOVE
The photographer was ready with his camera, quietly waiting to see how Jamie would treat his young guest. And because the photographer was unobtrusive, he was able to capture a very personal and tender moment.

14

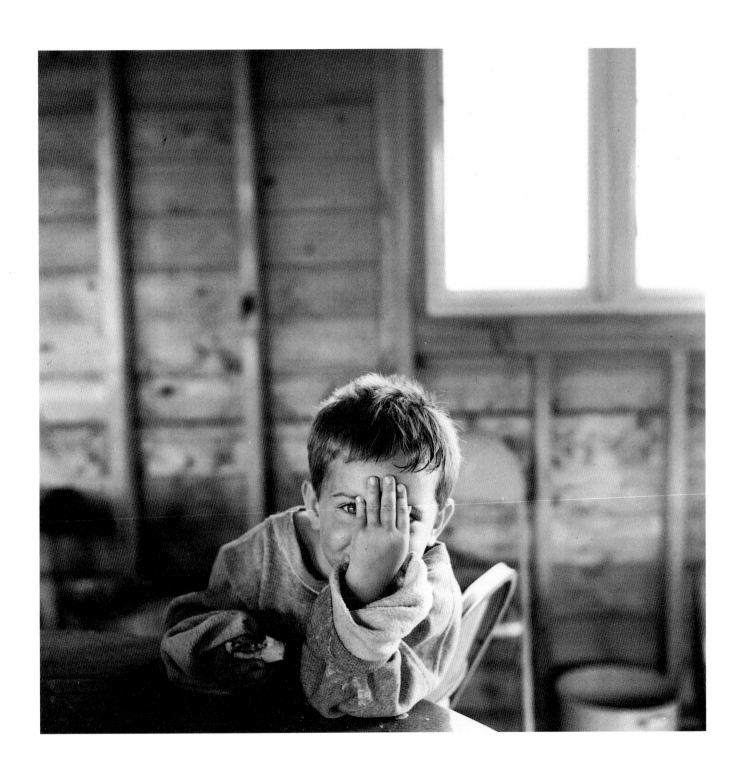

SOLITUDE, 1959
Jacques Lowe, American

Some photographers specialize in *celebrity* photography. They photograph movie stars or pop music idols and sometimes political figures. These two pictures are about photographing a young and exciting politician.

It is always more difficult to photograph well-known people because so many people know, or think they know, what they are like. In addition, the celebrities themselves are often very particular about how they should be photographed. So the photographer has a responsibility to always be truthful in his observation, because here he functions as a historian as well as a photographer. Future generations will look at these pictures and form an opinion about the person photographed — in this case, the future president of the United States, John Fitzgerald Kennedy.

Because presidents are always surrounded by other very important people, it is necessary for the photographer to be nearly invisible. He has to observe with a very keen eye, and catch the moment, almost as a sports photographer would. Unless he is alone with his subject, he cannot tell him how to move or what to do. The photographer must be like a "fly on the wall." He must see without being seen. Today, this is made easier because of high speed film and the hand-held camera.

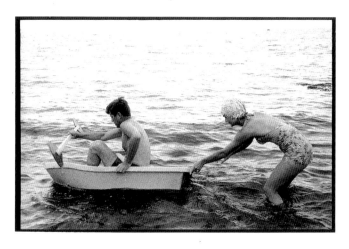

Jacques Lowe, ROMPING IN HYANNIS PORT
Here we see the president in a very different mood. He and his wife Jacqueline are having fun in a little rowboat on a carefree summer day.

The photograph opposite catches the future president in a very somber mood. He had just failed to convince a group of workers to accept him as their candidate. Standing alone against a bleak seascape, his coat black, his head bowed, the picture clearly portrays his disappointment. Of the forty thousand pictures the photographer took of John F. Kennedy, this is the photographer's favorite, because it reveals much about the private feelings of a very public person. It makes us realize that even presidents are human beings who feel, rejoice, and suffer as we all do.

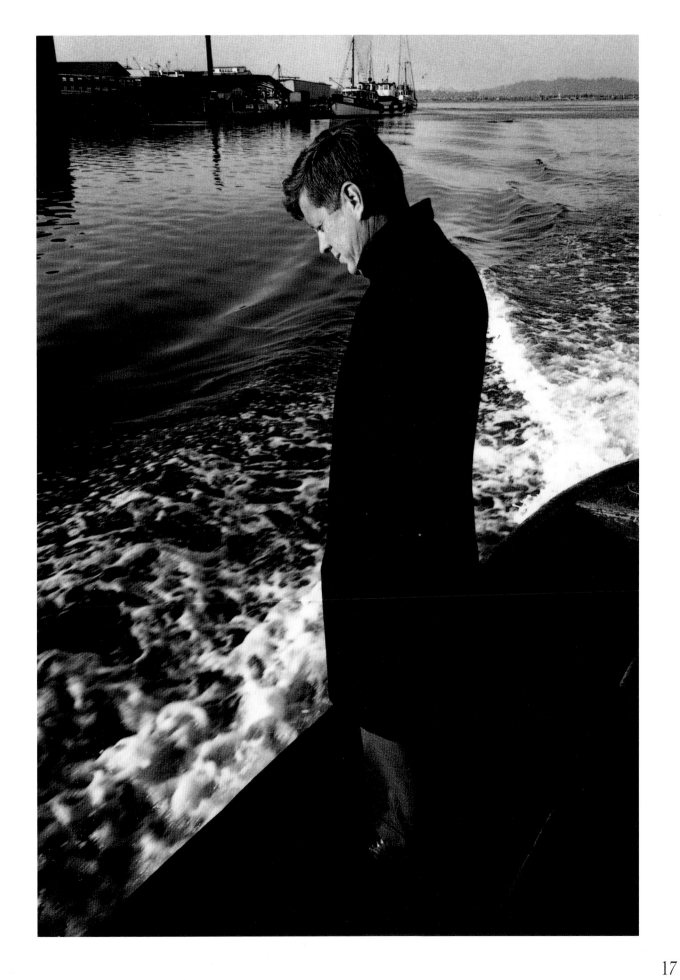

EMBRYO, 1965
Lennart Nilsson, Swedish

Lennart Nilsson's micro-photographs of a fetus inside its mother's body stunned the world when they first appeared. No one had ever seen what a baby actually looks like before it is born, and how it grows from month to month.

To create these pictures, Nilsson adapted newly invented optical devices to his needs. Because of the darkness inside the human body, Nilsson used a device called a scanning electron microscope that could magnify tiny tissues from up to 60,000 times. This microscope uses a beam to scan the interior of the body, and like a television camera produces an image on a screen, which can then be photographed.

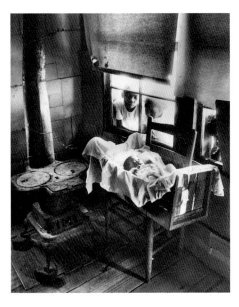

W. Eugene Smith, NURSE MIDWIFE ESSAY
In this picture, two little boys admire a baby just born. The photographer is concerned here with telling a story of the barren environment into which the baby was born.

At first, Nilsson concentrated on showing how a baby grows inside the mother's body — from a minute cell invisible to the human eye to a small organism called an embryo — from one-fifth of an inch long and less than two grams in weight to a fully developed person, weighing seven or eight pounds. Eventually, Nilsson explored the whole body — the skin, the heart, the lungs — in what amounted to a journey of discovery, just like a journey to discover foreign lands and people.

Nilsson's micro-photographs are very beautiful. The baby, floating in space inside an egg-shaped sack against what resembles a starry sky, looks as though it was carefully posed. The colors — red, yellow, and brown — are a perfect combination. And some of Nilsson's later pictures of the body look more like landscapes than microscopic pictures.

Nilsson is both a photographer and a scientist. His pictures are used in medical research to find out how the body functions and how to keep it healthy. When photography was first invented, it took large, heavy, and awkward cameras that needed long exposures in order to make a picture. Now we can photograph through microscopes. Today, photographers can photograph hidden and nearly invisible things. Photography, more than any other art form, makes use of the emerging technology of the computer, and soon we will be able to photograph without using a camera at all.

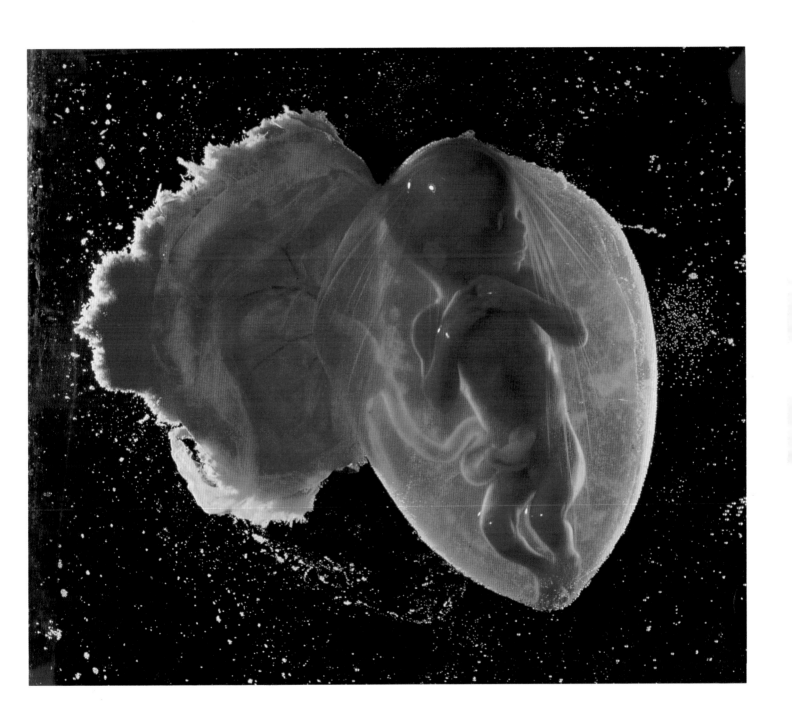

HOW I WON THE WAR, 1968
Douglas Kirkland, American

Douglas Kirkland grew up in a small town in Canada. From an early age, he dreamed of movie stars. Every week he looked forward to LIFE magazine, whose pictures showed how famous people lived. One picture especially made him decide to be a photographer. It was a picture of Fred Astaire, a famous actor and dancer, sitting at his piano. The picture was one of the first using a *35mm camera* without a flash. The natural light and casual air of the actor, unaware that he was being photographed, gave him a very real look.

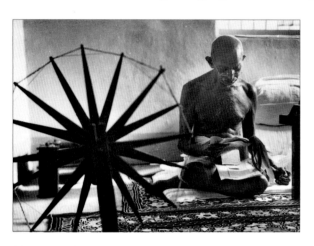

Margaret Bourke-White, GANDHI, 1946
Margaret Bourke-White went to India to photograph Mahatma Gandhi. Her picture showing Gandhi at the spinning wheel on which he made his own clothes, rather than as a world leader, highlights his humility.

After high school Kirkland got a job working for the local newspaper. He photographed high school games and local dances. But he felt that to become a successful photographer he had to get to New York City. When he arrived there, he was lucky to get a job as an assistant to a photographer who photographed many famous people.

Assistants help photographers with everything they do. They carry cameras and *tripods* on *location*, they work in the *darkroom* and make *prints*, they help in the *studio* before a picture is taken by moving *props* into place and making sure the right background paper is hanging, and they assist the photographer while he takes the picture. Douglas loved doing all these things, especially being face to face with the people he had always dreamed about.

But Kirkland didn't get to take his first celebrity picture until years later. By then he was a *staff photographer* for a picture magazine. He met Elizabeth Taylor and told her that if she would let him photograph her it would greatly help his career. She agreed. Since then, Kirkland has photographed many celebrities.

This picture of the musician John Lennon was taken on a movie set in Spain. During a relaxed moment between filming, Kirkland suddenly saw an interesting reflection in Lennon's glasses. He shouted to him from across the room and Lennon looked up and smiled. Because the photographer reacted to a mere glint in Lennon's eyeglasses, suddenly and unplanned, Lennon's expression is very genuine and unposed.

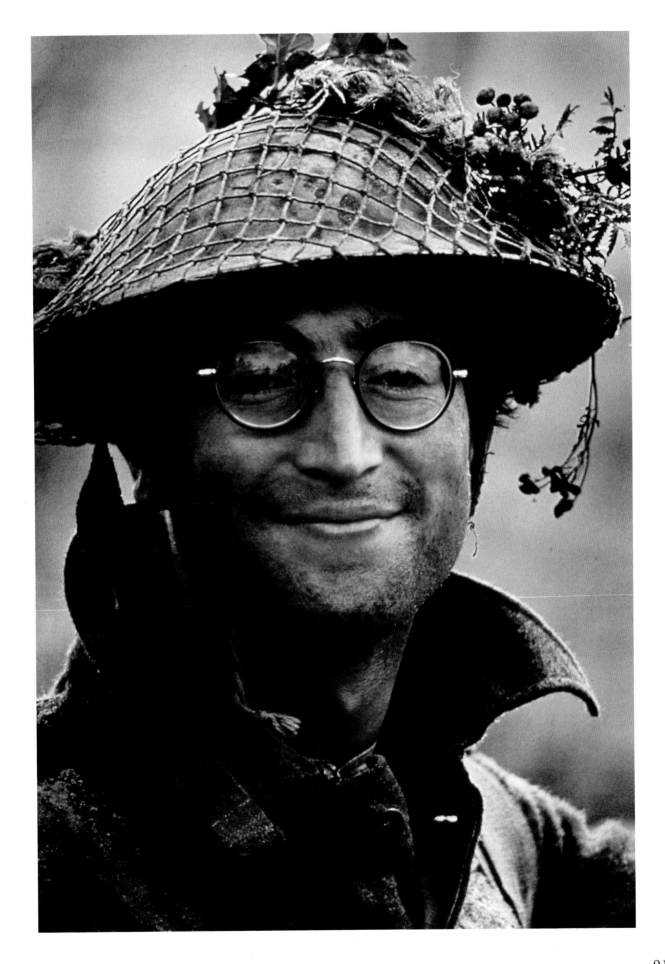

DREAM SEQUENCE, HAND ON DOOR, 1969
Ralph Gibson, American

Photographers, like painters and filmmakers, see things differently. Some photographers' eyes are drawn to the core of an image — a person, a tree. Some see the image in its context or environment — within a room, a city, a landscape. Ralph Gibson closes in on details. By doing so, he forces the viewer to imagine the rest of the picture.

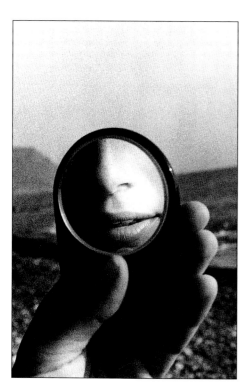

Ralph Gibson, MIRROR AND LIPS
Although this photograph is less abstract than the photo opposite, we still wonder about the woman and what she is doing.

This simple image of a hand on a door being opened evokes all kinds of ideas. There is a sense of suspense about it. We know it is daylight, probably morning, because the sun is streaming through. But we wonder whose hand it is. Is it a woman's hand? Why is she there? What is her intention? Is she simply opening the door to go out? Or is she closing the door behind her as she is leaving the room? Is the room furnished? What kind of room is it? Are there other people present? The questions are endless. It is a detective picture, a puzzle. Gibson calls it *Dream Sequence*.

Gibson calls his work the "framing of ideas." In other words, to him, the photograph is created by the mind. The camera is purely incidental. When we look at one of his photographs showing a lock of hair, or a foot, or simply a shadow falling onto the street, we are never satisfied. We always wonder what the photographer is up to.

So when you take a picture yourself, you should know that you can take pictures of exactly what you see, or you can change what you see into your own dream. You can frame a picture of your friend playing ball, for instance, in many ways: show your friend playing ball with the street or stadium behind him (he becomes smaller), or take a close-up photograph of your friend's hand on the ball and leave the rest to the imagination.

The way in which photographers often see the same thing so very differently, the way they apply their own vision to subject, is what makes each photographer an individual artist.

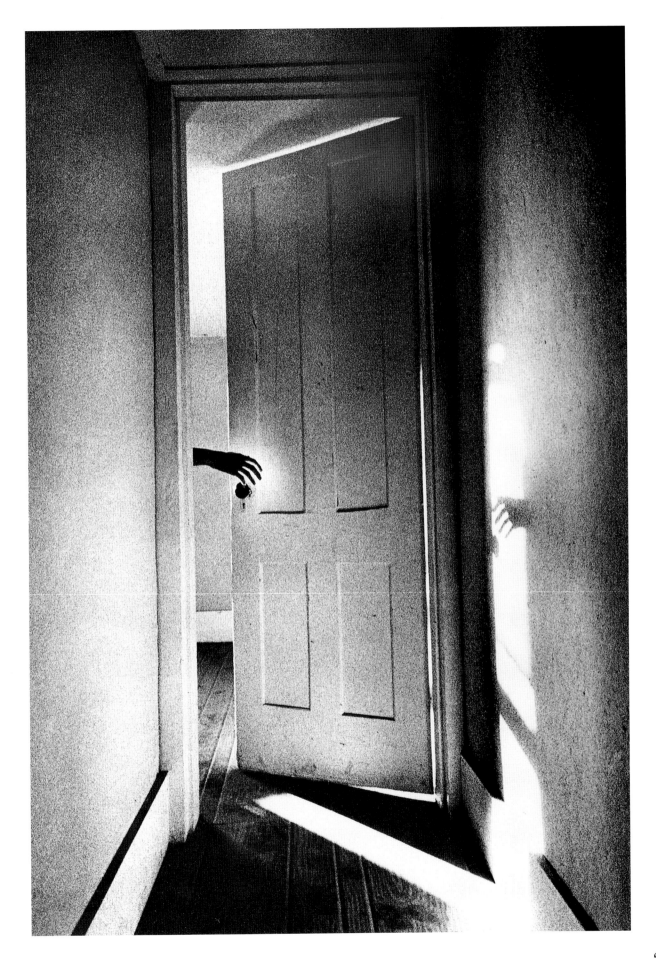

23

ALGERIA 1973
Jean Mohr, Swiss

Whenever a photographer lifts his camera to take a picture, he always has to think about scale. Should he use a *wide-angle lens* to place the subject firmly in the environment and to let us see the surroundings? Should he use a medium-range lens to include just a few objects surrounding the subject — a tree or a bit of road to give us a hint of where the picture was taken? Or is the surrounding area of no importance? In that case, he might use a *telephoto lens*. It is a very important decision to make, and often it has to be made in seconds. Through that process of selection, the photographer makes us see what he wants us to see, and what he thinks is important. Only he knows what else happened at the time the photograph was taken.

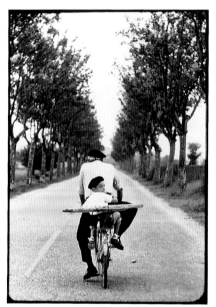

Elliot Erwitt, FRANCE
Details in a composition can give us many clues about where the picture was taken.

Here are two examples of the use of scale. Jean Mohr decided to tell us something about Algeria. He wants us to know that it is a country made up of deserts, so he shows us sand dunes reaching all the way to the horizon. The small figure pedaling the bicycle is included to let us know how vast the desert is. We understand instantly. Take away the person on the bicycle, and we would have no understanding of the scale of the landscape.

Mohr took this picture with a wide-angle lens. He waited to click the *shutter* until the bicyclist was exactly in the center of the lightest part of the landscape. He needed the contrast of the *silhouette* to emphasize the *scale*. Had he taken the picture a second earlier or later, the effect would have been lessened and the balance of the picture would have changed as well. Exposing the photograph at that precise moment gives the picture perfect *symmetry*.

In the picture on the left, we also see a bicyclist. But the photographer only hints at the surrounding countryside. Instead he concentrates on the people and, by showing us *details*, he tells us something about these people. Both the young boy and the man wear a French cap called a beret, and a long, thin loaf of bread, called a baguette, is tied to the back of the bicycle. By observing the details in this picture we can guess that we are in France. In different ways, both pictures make clear where they were taken.

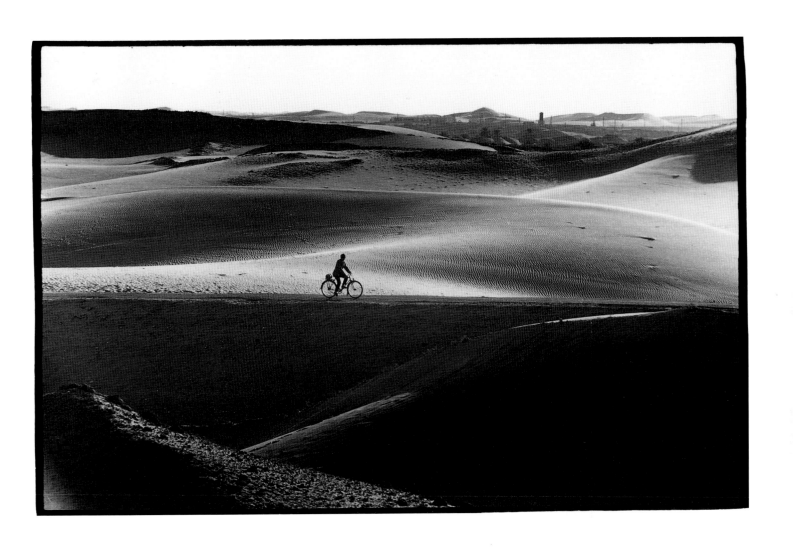

25

CAFE IN VAUCLUSE, FRANCE, 1979
Willy Ronis, French

Photographers have joined expeditions to the arctic circle, searched for tribes living in remote jungles, crossed the Sahara Desert, and taken a camera to the moon. And because of their photographs, we know a great deal more about foreign countries and their customs than our ancestors did.

Some photographers concentrate on photographing the countryside. They are called *landscape photographers*. Through them, we know what a banana tree in Central America looks like and how tall the California redwoods are.

Others prefer to photograph different forms of wild life. Through photographs we can see how eagles fly and whales swim. We can see the many colors of tropical fish and discover that plants grow on the ocean floors. And yet other photographers focus their lenses on people — their customs, the way they dress, how they dance, sing, and enjoy themselves, and how they relate to one another. Sometimes the most informative pictures are those that depict ordinary, everyday life.

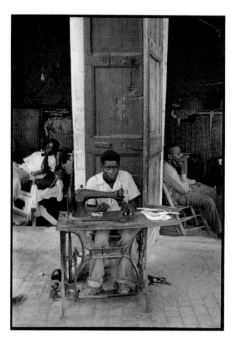

Jacques Lowe, TAILOR SHOP, HAITI
This photo also is a street scene. Again, not much is happening. But the scene clearly tells us that we are not in Europe, but on a different continent.

This *street photograph* of a café in a small town in France tells us a lot about that town. Not much is happening. The fifteen people who are visible are mostly absorbed in conversation. All of them are very relaxed. It is daylight. There are children in the picture and shoppers, so it is probably a Saturday. The woman in the center is obviously the owner of the café, making sure all is well. We see a loaf of French bread on one table, and signs written in French. So even if the placard over the door didn't say "Café De France," we know that we are in a small town in France by studying the details in this photograph.

If you take photographs when you travel, always make sure that some part of the picture you take tells us something about where you are. Picturing the people, their houses and shops, the animals, plants and trees natural to the place you are visiting, even signs in foreign languages, will later give you wonderful memories. And if you capture the spirit of a place you can show others who have never seen it what your experience was like.

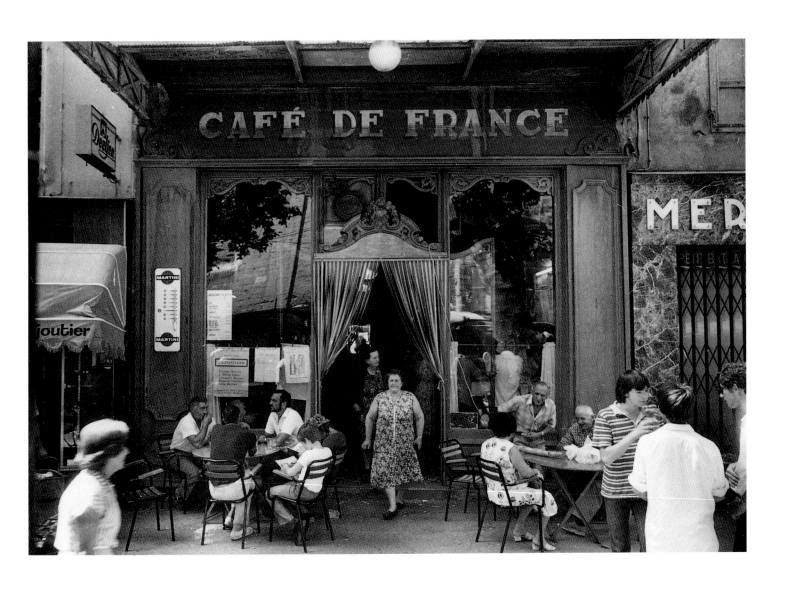

JAMES T. BRUNSON, RED COUCH, 1983
Kevin Clarke, American

Sometimes photographers set themselves nearly impossible tasks. They have an idea that goes beyond everyday events and they become passionate about it. In this case, Kevin Clarke and Horst Wackerbarth decided to take a red velvet couch around the United States and to ask people from all walks of life to sit in it. They set off separately carrying identical eight-foot-long, two-hundred-pound couches around the United States—by truck, plane, barge, helicopter, and a ski lift. Clarke even wanted to photograph the couch weightless. He underwent ten days of astronaut training, and the couch nearly made it into space!

The idea seemed crazy. People laughed at it, but the couch became a focal point in an ever changing landscape and the people sitting in it—farmers, cowboys, admirals, gamblers, astronauts, movie stars, millionaires, the homeless-became unified parts of a diverse nation. Eventually LIFE magazine and other journals around the world published the pictures as a genuine attempt to explain America.

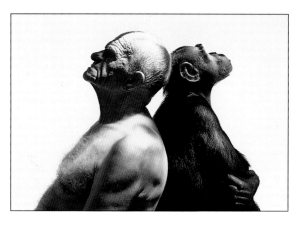

James Balog, MAN AND APE

James Balog, through this picture of a man and a chimpanzee, also surprises us with the unexpected. But his vision and intent is to show the path of evolution by pointing out the closeness and similarities still existing between human beings and apes.

To make these pictures, called *environmental portraits*, accurately reflect the environment in which the sitter was placed, it was essential that the image, from close-up to the distant background, be sharp. This made it necessary to use a 4" x 5" view camera, mounted on a tripod to hold the heavy camera steady. The large negative gives a very clear picture. And the smaller opening in the lens's *diaphragm* makes the image sharper. Also, by using such a large camera rather than a handheld one, people were made aware that the taking of these photographs was a special occasion.

The project took four years to complete. It exhausted the photographers' financial and emotional resources. They ended up nearly penniless. But the pictures ultimately made them famous.

By using an ordinary piece of furniture as a prop and placing it into unexpected and sometimes bizarre locations, the photographers made us pay special attention and forced us to look at the world around us in a different way.

DALEY THOMPSON, DECATHLON HURDLER, 1984
Gilles Peress, French

Speed and movement have fascinated photographers from the moment the camera was invented. In the nineteenth century, the English photographer Eadward Muybridge explored how people and animals moved. He showed how people walked, horses galloped, wild animals jumped, and birds flew by making *multiple exposures* in rapid succession. It was the first time movement was captured on film.

Ever since, inventors have been challenged to search for new ways to capture speed on film. *Shutters*, the part of the camera that controls the amount of light hitting the film, became so fast that exposures were no longer measured in seconds, but in fractions of seconds. *Flash powder* created a sudden burst of bright light allowing quicker exposures. Eventually, dangerous flash powder was replaced by much safer *flash bulbs*, and finally, in 1931, a scientist named Harold Edgerton invented the *electronic strobe light*, which is still being used today. *Strobes*, as they became known, take pictures at the speed of 1/10,000 or even 1/100,000 of a second. Such speeds literally freeze the photo, making it pin-point sharp.

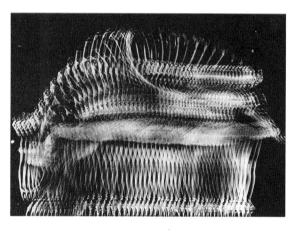

Gjon Mili, PAS DE BOURRÉE

Mili was one of the first photographers to explore the strobe light. This multiple exposure *on one piece of film, of a ballet dancer walking on her toes, is a fine example. Without the strobe freezing each image, this picture would have been totally blurred.*

To fully document the drama of sport, the photographer needs that speed. This picture of a hurdler was taken in bright sunlight at perhaps 1/1000th of a second. The photographer dramatized the action by *centering* on the athlete's legs. We see the muscles straining and realize that the hurdler barely clears the hurdle. But at the same time, Peress also shows us the whole athlete by including the athlete's shadow. Although this picture was taken in a split second, the photographer was able to pay attention to everything unfolding before him. When you take a photograph, it is important to observe what happens around your main subject, and to try to balance the background with the main subject.

Composition is very important and must never be compromised, whether a picture is taken in an instant or is carefully planned. Composition is one of the elements that makes a photographer's work special, personal, and unique.

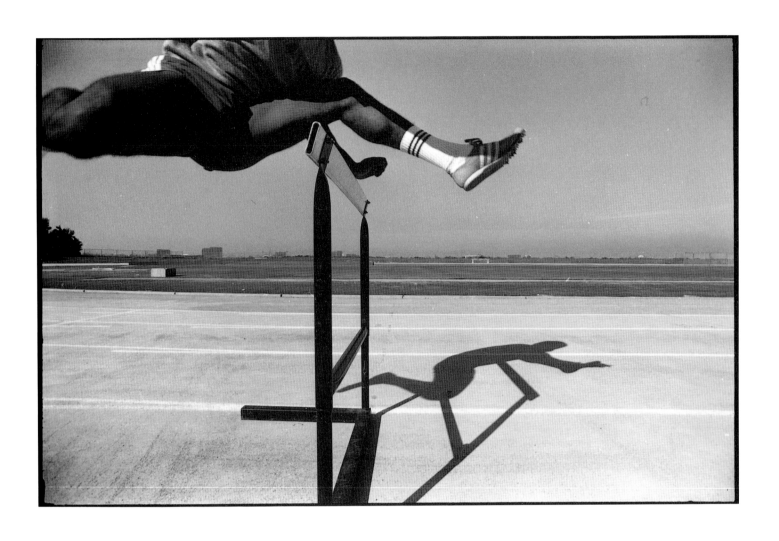

ELLEN STEWART, 1988
Brian Lanker, American

Photographers work in many different ways. Some carry a camera at all times and take pictures whenever something catches their eye. Others set themselves specific tasks.

Brian Lanker decided to photograph African-American women who had made our world better through their achievements. Having made that decision, he had to determine what constituted achievement, and find out which women were the most accomplished in their fields. This is called *research*, and is an important part of any job. He finally settled on seventy-five women. Next he had to determine how to photograph them. Should he use a small, *hand-held camera* to capture them at work, or picture them another way? He decided that portraits, taken with a large camera and large-sized negatives assuring maximum quality, would be the best way to accomplish the task he had set for himself. So Lanker, his assistant, and a great many boxes of camera equipment set out to crisscross America to meet and photograph his chosen subjects.

A fine portrait is not simply a picture of a person. It reveals something unique about the personality of the subject. Therefore, it is important for the photographer to get to know the subject and to learn how the subject sees herself. Because of this, Lanker's photo sessions sometimes took hours. It took two years to complete the entire assignment.

Ellen Stewart, the woman in this picture, is the founder of a famous theater in New York called La MaMa. The theater is very successful and she is a happy woman. The picture shows it, and that is the reason why this portrait is successful. Although we may not know at once by looking at the photograph who the woman is or what she has achieved, we still learn a great deal about her just by looking at the picture.

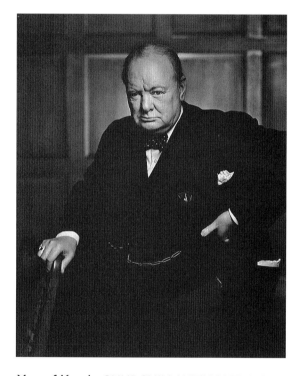

Yousef Karsh, CHURCHILL WITHOUT CIGAR
This picture of the Prime Minister of Great Britain during World War II is very famous. Just before the photographer clicked the shutter, he went over and took a cigar out of Churchill's mouth. This made Churchill very angry, and resulted in his tough and determined expression.

DANIEL EZRALOW AND ASHLEY ROLAND, 1989
Lois Greenfield, American

Lois Greenfield started her life in photography as a *photojournalist*. She worked for newspapers and magazines covering many subjects. She found she was very attracted to dancers and their work. She was fascinated by the process of photographing movement.

Of all the arts, dance is the most difficult to photograph because dancers are constantly moving. A photograph makes a figure stand still, freezes it, and squeezes all the action into one frame. The movement has therefore to be imagined, leaving it to the photographer to catch the most crucial moment in a dance in order to give the illusion of movement.

Early in this century, before the invention of the flash bulb and the strobe light, when long exposures were needed to record an image, dancers had to be held up by cables so they could hold their poses for a picture. But the electronic strobe light changed all that. Greenfield places her dancers in front of a neutral background in her studio and lets them move. The resulting photographs look very spontaneous. But some of her pictures are, in fact, elaborate productions needing props, assistants, split-second timing, and teamwork among the photographer and her subjects. Don't believe that everything you see in a photograph just happened accidentally. Often what you see is an elaborate creation.

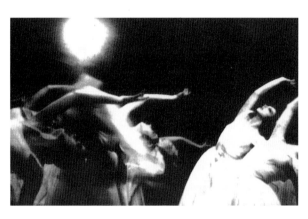

Alexei Brodevitch, THE DANCE
While Greenfield's pictures are very sharp and crisp, Brodevitch's pictures of dancers are blurred. To him, the movement was more important than the dancers.

This photograph of two dancers in mid-air, their bodies intertwined, their hair flying, their arms and legs twisted into seemingly impossible positions, is typical of the spirit of Greenfield's work.

When photographing movement, the photographer has to decide what is more important: the movement itself or the people who are moving. Depending on that decision, the photographer will either use a high shutter speed to catch a sharp image of the subject, or a low shutter speed to get the blur of movement. Greenfield chose the first, and Brodevitch the latter.

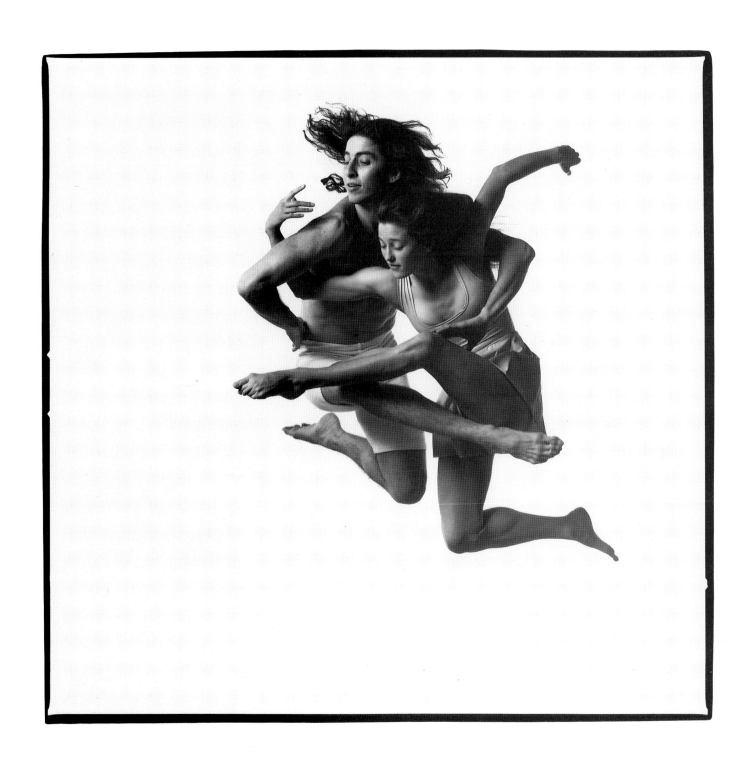

CONTORTIONIST WITH HER PUPPY SWEETY, GREAT RAJ KAMAL CIRCUS, UPLETA, INDIA, 1989
Mary Ellen Mark, American

Mary Ellen Mark had a dream. On a trip to India in 1969, she fell in love with the country and was especially struck by the colorful Indian circuses. Over the next twenty years, she returned to India many times on different assignments, each time more certain that one day she would return and focus her attention on the exciting circuses. In 1989 her dream came true, and she spent a year travelling through India by car, bus, train, and airplane visiting eighteen different circuses and photographing their magic.

The portraits she took of jugglers, trapeze artists, clowns, and animal trainers, and their lions, tigers, or elephants look very simple, but in fact they were complicated and sometimes dangerous. It often took hours to get the animals to relate to their trainers in a way that would make a good photograph. The animals would often walk away ignoring the camera. And standing inside lions' cages with a camera sometimes became very scary.

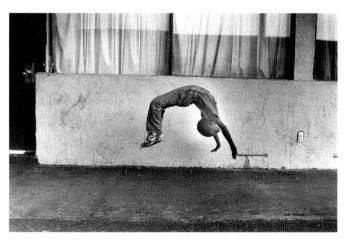

Daniel Hall, FLIP
Daniel Hall, a twelve year old photographer, never left his neighborhood to take this picture of his acrobatic friend.

Mark used two cameras, a small *35mm camera* that makes an oblong picture and a slightly larger camera that makes a square picture. Many of the pictures she took are of the children who perform acrobatic acts. This portrait of a little girl tells us a lot about her and the circus. The pose shows us that she is an acrobat who can twist her body any way she wants to. Her face is on the ground, but we can't see her hands. The small, black dot between her eyes tells us that she's Indian and a Hindu, which is an Eastern religion.

Mark says that she is very lucky to be a photographer and, through her work, is able to experience so many different things. She makes her photographs to share these joyous experiences. Some photographers are journalists, some see themselves as artists, but most all of them, in sharing their experience, are teachers.

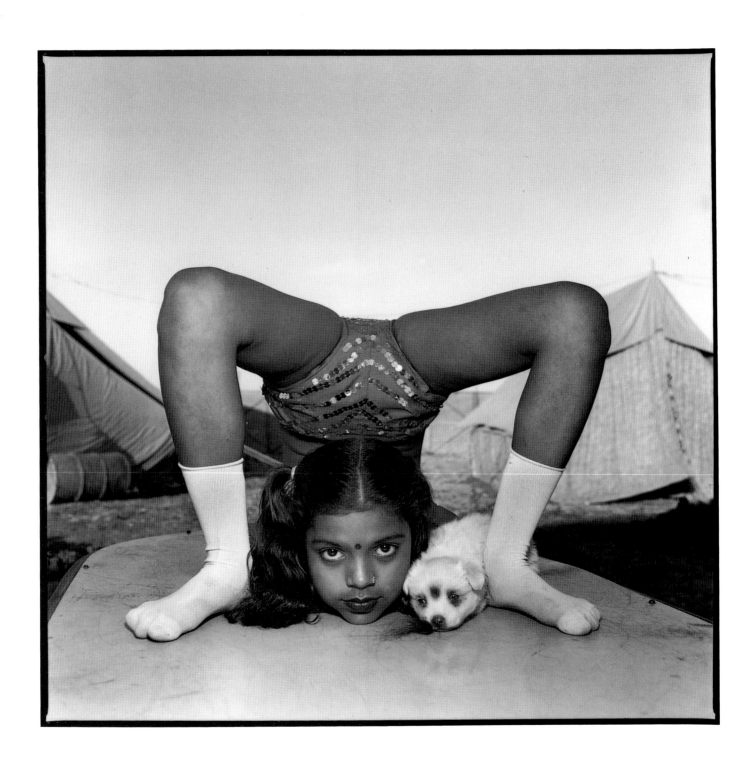

THE SUPREMATISTS, 1990
Serge Lutens, French

One of the most difficult areas of photography is *commercial photography,* especially the part called *advertising.* Not only does the photographer have to take a picture in accordance with what he thinks is the way to best show a product, but he also has to satisfy the client's view of the *product.* Generally, when a company wants to advertise its product, it calls an *advertising agency.* The advertising agency contacts a *creative director,* who proposes different ideas for showing the product in the best way. The creative director calls in an *art director,* who makes drawings called *layouts.* These layouts show the photographer what kind of image the company wants.

The most challenging of all advertising pictures are fashion pictures. The best *fashion photographers* create images that only exist in their imaginations. In order to make these dream images succeed, beautiful models are made even more glamorous by an army of attendants who specialize in beauty — *fashion designers, make-up artists, hairdressers,* and *stylists* who choose such things as earrings, necklaces, bracelets, and other *accessories.*

Serge Lutens is one of the masters in his field. He is also unique in that he is able to do all the things mentioned above himself. He functions as the advertising agency, the creative director, and the art director, as well as the make-up artist, hairstylist, photographer, and writer. He designs his own lighting, stage sets, costumes, and accessories.

This photograph was made for a Japanese company that manufactures beauty products. The products advertised, lipstick and eyeshadow, are shown very clearly and realistically. The color of the lips and eyes of this model stand out against the face, which has been whitened to enhance contrast. The model is wearing a black full-length leotard. The studio background is also black. Lutens assembled the machinery using old parts from real industrial machines, then painted them red and placed them in front of the model. No special mounts, no *retouching,* no computers were used. This photograph again shows that there are no limits to the way a photographer interprets his vision.

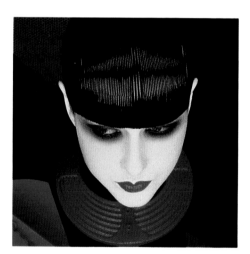

DETAIL OF HEAD AND NECKLACE
Because the model has black hair and is photographed against a black background, the photographer carefully highlighted her hair with a tiny spotlight, called a pencil light.

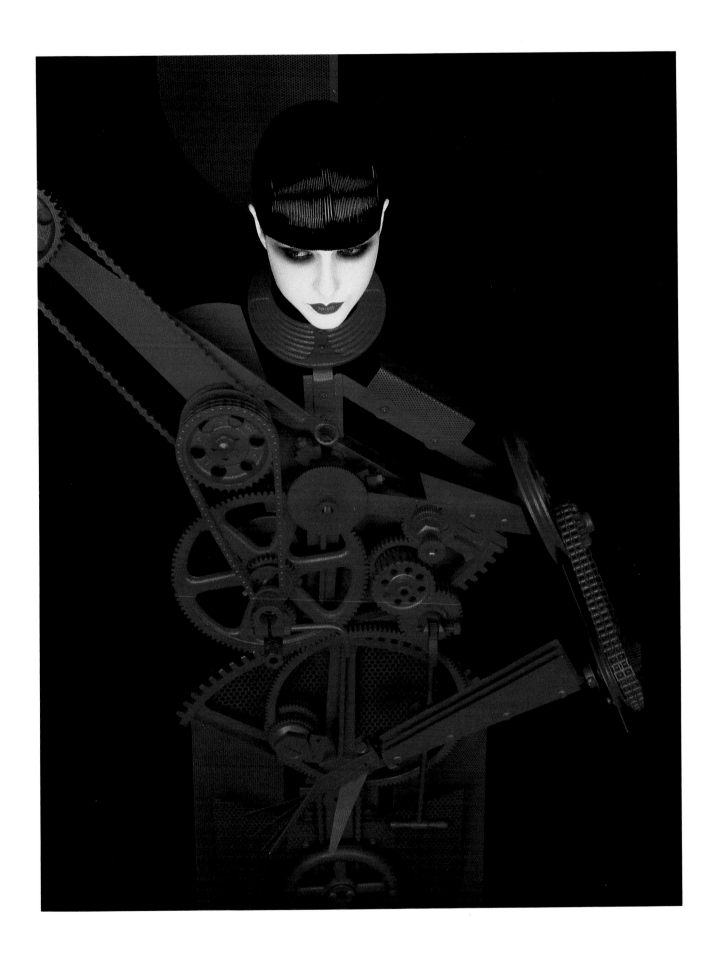

Glossary

35MM CAMERA: small, lightweight camera designed to be hand-held, using film

BACKGROUND PAPER: paper: used to create an even background for a picture

CANDID PHOTOS: unposed spontaneous photographs

CENTERING: placing a subject in the center of the photograph

CLOSE-UP: an extremely close view of a detail within a photo or of a tiny object

COMMISSION: a job assignment to take specific photographs for a client

COMMERCIAL PHOTOGRAPHY: photographs made to advertise a product or a concept

COMPOSITION: the arrangement of all the elements in the photograph

DARKROOM: a room that is kept dark for developing film and making prints

DEPTH OF FIELD: the area within a photographic image which is in sharp focus

DEPTH OF FOCUS: same as above

DIAPHRAGM: the device that opens or closes a lens, thereby controlling the amount of light that reaches the film

DOCUMENTARY: a film or a series of photographs about a real event

DOCUMENTARY PHOTOGRAPHER: a photographer who specializes in recording actual events

ENVIRONMENTAL PORTRAITS: a portrait that includes the area surrounding a subject

EXPOSURE: the shutter speed with which a photo is taken combined with a larger or smaller opening of the lens. The combination of the two elements results in the picture being too light, too dark, or just right

FLASH BULBS: bulbs that create a flash of bright light, used to illuminate a dark scene

FLASH POWDER: the powder that was used before the invention of the flash bulb.

GLASS PLATES: glass sensitized with silver for taking pictures, used before the invention of film

GOLD CHLORIDE: a powder used to color photographs

HANDHELD CAMERA: a camera lightweight enough to be used without a tripod

HIGH-SPEED FILM: film that is extremely sensitive to light, thereby making it possible to take pictures in bad light or to shorten exposure time

LANDSCAPE PHOTOGRAPHERS: photographers who specialize in photographing natural settings

LAYOUTS: the organization of words and pictures on a page

LOCATION: a place outside of the studio used as the setting for a photograph

MULTIPLE EXPOSURES: photographs taken in rapid succession, generally of the same subject

NEGATIVE: film that reverses an image from positive to negative. On the negative dark shades register light and light shades dark. When making a print from the negative the image is reversed back to normal, or positive

PERFORATION EDGE: the notches on the edge of a film perspective: a panorama, a vista, or the angles of a picture

PHOTOJOURNALISM: photography that concerns itself with news events

PHOTOJOURNALIST: a photographer who photographs news events such as wars or demonstrations

PORTRAIT: a posed photograph of a person or animal

POSE: to take a stance in front of a camera

PRINTS: a picture large enough to view

PROPS: objects used to enhance a photograph

RETOUCHING: improving or altering a photograph by hand or computer

ROLL FILM: film rolled on to a spool

SCALE: the relationship of size between various objects within the picture frame

SEPIA: a color ranging from deep yellow to dark brown

SHUTTER: the device in the camera that controls the speed with which a photo is taken

SILHOUETTE: the outline of a black shape against a lighter background

SNAPSHOTS: an instant exposure

STAFF PHOTOGRAPHER: a photographer who is employed by a magazine, newspaper or organization

STREET PHOTOGRAPH: a photograph that depicts ordinary, everyday life

STUDIO: the room in which a photographer or painter works

STYLISTS: specialists who select the clothes and accessories models wear

SYMMETRY: shapes and lines that are in equal balance towards each other and in perfect harmony

TELEPHOTO LENS: a lens used to bring distant subjects to within photographic range

TONED: to change a black and white image into a different, but monochrome, color such as brown and white, or blue and white

TRIPOD: a stand with three legs used to support a heavy camera

VIEW CAMERA: a large camera on which the front and back elements can be manipulated in order to control perspective

WIDE-ANGLE LENS: a lens that covers at least a 135-degree view

Credits

Page

4 *BICHONNADE IN FLIGHT,* 1905
Jacques-Henri Lartigue, © Association des Amis de J.H. Lartigue

5 *ORGAN GRINDER,* c.1901
Jean-Eugène Auguste Atget

6 *ARVOL LOOKING HORSE,* 1994
© Dan Budnik, Woodfin Camp & Associates

7 *BEARS BELLY-ARIKARA,* 1908
Edward Sheriff Curtis, Courtesy

8 *CIRCUS HANDS,* 1954
© Jacques Lowe

9 *POWERHOUSE MECHANIC,* 1920
Lewis W. Hine, Courtesy George Eastman House

10 *GOLDMINERS,* 1986
© Sebastiao Salgado, Magnum Photos Inc.

11 *MIGRANT MOTHER, NIPOMI, CALIFORNIA,* 1936
Dorothea Lange, Courtesy Library of Congress

12 *IN FRONT OF THE NURSERY SCHOOL IN THE INDUSTRIAL SECTION,* 1931
© Hans Staub

13 *NEW YORK,* 1940
© John Phillips

14 *FIRST LOVE,* 1958
© Jacques Lowe

15 *NOW YOU SEE ME...,* 1959
© Jacques Lowe

16 *ROMPING IN HYANNIS PORT,* 1960
© Jacques Lowe

17 *SOLITUDE,* 1959
© Jacques Lowe

18 *NURSE MIDWIFE ESSAY,* 1951
W. Eugene Smith, © 1951 *Life* Magazine, Time Warner Inc.

19 *EMBRYO,* 1965
© Lennart Nilsson, From *A Child is Born,* Dell Publishing

20 *GANDHI,* 1946
Margaret Bourke-White, © *Life* Magazine, Time Warner Inc.

21 *HOW I WON THE WAR, SPAIN 1968,* 1968
© Douglas Kirkland

22 *MIRROR AND LIPS*
© Ralph Gibson

23 *DREAM SEQUENCE, HAND ON DOOR,* 1969
© Ralph Gibson

24 *FRANCE*
© Elliot Erwitt, Magnum Photos Inc.

25 *ALGERIA,* 1973
© Jean Mohr

26 *TAILOR SHOP, HAITI,* 1956
© Jacques Lowe

27 *CAFE IN VAUCLUSE,* 1979
© Willy Ronis

28 *MAN AND APE,* 1993
© James Balog

29 *JAMES T. BRUNSON,* 1983
© Kevin Clarke

30 *PAS DE BOURRÉE,* 1947
Gjon Mili, © *Life* Magazine, Time Warner Inc.

31 *DALEY THOMPSON, DECATHLON HURDLER,* 1984
© Gilles Peress, Magnum Photos Inc.

32 *CHURCHILL WITHOUT CIGAR,* 1941
© Yousef Karsh, Woodfin Camp & Associates

33 *ELLEN STEWART,* 1988
© Brian Lanker

34 *THE DANCE*
© Alexei Brodevitch

35 *GDANIEL EZRALOW AND ASHLEY ROLAND,* 1989
© Lois Greenfield

36 *FLIP,* 1989
© Mary Ellen Mark/Library

37 *CONTORTIONIST WITH HER PUPPY SWEETY, GREAT RAJ KAMAL CIRCUS, UPLETA, INDIA,* 1989
© Mary Ellen Mark/Library

38 *DETAIL: THE SUPREMATISTS,* 1990
© Serge Lutens

39 *THE SUPREMATISTS,* 1990
© Serge Lutens